Photo Tinting

By Ed Krebs
with William F. Powell

Walter Foster Publishing, Inc.
23062 La Cadena Drive, Laguna Hills, CA 92653
www.walterfoster.com

Contents

Introduction

The desire to add color to a photograph was probably born about ten seconds after the first black-and-white print was made. Adding color to prints with paints and dyes dates back to the middle of the nineteenth century, when the only way to get a color print was to hand color it. The practice all but faded away when color film was introduced, but now it has been reborn as an art form. Photo tinting is no longer an attempt to imitate color photography; it's a special artistic and photographic technique.

Almost any medium can be used to color photographs, but photo tinting is a particular technique that allows the print to show through the color. After introducing you to some basic materials, I will share the oil and dye techniques that I prefer, which are basically the same techniques that have been used by colorists for the past 100 years. In the third section of the book, artist William F. Powell (Bill) will introduce you to some alternative ways to tint photos with colored markers, watercolors, colored pencils, and oil pastels. Of course, you won't have the same photos we used for demonstration in this book, but the techniques are universal and can be applied to any photo you choose.

The best-kept secret about photo tinting is how easy it is. So get out your camera or pull out your favorite black-and-white prints, and start tinting!

Before Here's a black-and-white print just waiting to be hand tinted.

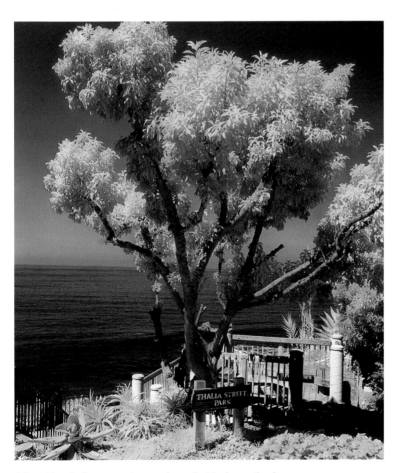

After Here is the same print transformed with photo oil colors.

I. Selecting Your Materials

TINTING WITH OILS AND DYES

Hand coloring photos with oils and dyes doesn't require many special tools. Basically, you'll need your chosen coloring medium, a palette, cotton swabs and balls, one or two brushes, and—most important—photographs.

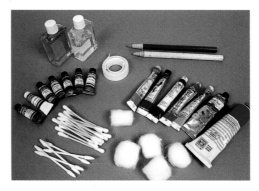

Basic Supplies These are the materials you'll need for tinting photographs with oils: tubes of photo oils, tubes of artists' oil colors, cotton balls, regular and pointed cotton swabs, oil and alcohol solutions, a roll of artists' tape, and stick erasers.

Paint Applicators

If you are tinting with oils, the best tools for applying the colors to your print are regular and pointed cotton swabs, which are readily available at your local drugstore. For buffing the paint, get 100% genuine cotton balls (synthetic cosmetic puffs don't pick up the oils).

You should also have a couple of small, fine-tipped brushes to paint details and to cover up scratches with spotting dyes (see page 12). If you are going to use different coloring media, buy separate brushes for each one; for example, use different brushes for oils, water-based colors, and

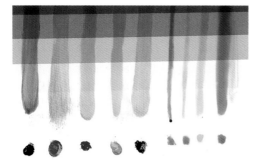

Testing Colors I try out my paint colors on a piece of unexposed photographic paper that has been processed and washed normally. The gray bands were created in the darkroom to show how the colors appear on different areas of a print.)

spotting dyes. A toothpick is also great for dotting paint on a small detail, such as the iris of an eye.

Color Palette

The list of colors below makes an excellent starting palette for most subjects, and these are the colors I used for the projects on pages 16–43. This palette should work successfully with any coloring medium, although you may profit by some experimentation and testing.

- 2 greens—a light and a dark
- 2 browns—a light brown, such as raw sienna, and a dark brown, such as Van Dyke brown or Verona brown
- 2 reds—a primary red, such as cadmium red or cheek red, and a blue-red, such as alizarin crimson or lip red
- 1 primary blue, such as ultramarine blue
- 2 yellows—a light yellow, such as cadmium yellow light, and a dark yellow, such as permanent Indian yellow deep
- 1 violet
- 1 orange

Colors for Flesh Tones

Since hand tinting has always been a favorite of portraitists, photo oils come in several shades of flesh. There is a color called "basic flesh," but it really is much too yellow. Instead, use a color called "Flesh No. 2." In artists' oils, burnt sienna is the closest match I've found to the flesh tones in photo oils. For darker skin tones, add a touch of brown. For pink tones, add a little cheek red and lip red to Flesh No. 2, and buff them till they're light.

Photo Oils

Although you can use several types of oil paints to color your photos, I believe that paints made specifically for photo tinting are by far the best choice. Called "photo oils," they are transparent enough to allow the photo to

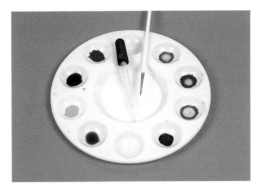

Pick a Palette For mixing paints, you can use almost anything—plastic palettes from art supply stores, wax paper, or jar lids. If your paints are very oily, typing paper or newsprint will soak up the excess oils.

show through, yet have enough pigment to provide bright colors. You can find them in individual tubes or packaged in kits at many larger photo and art supply stores. The kits usually contain cleaning and surface preparation solution as well. Although they may seem a bit expensive, photo oils are used so sparingly that they will last a long, long time.

Artists' Oil Paints

Regular artists' oils also work well for photo tinting, but the colors should allow the underlying print to show through. Look for the word *transparent* or *semi-transparent*.You can also make the colors more translucent by diluting them with thinning gel, a special solution that isn't repelled by oil.

Retouching Dyes

Water-based retouching dyes are the only coloring method I use other than oils. The dyes are made by several different manufacturers and are also used

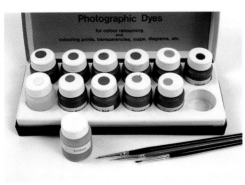

Dyes A set of dyes could very well last a lifetime, since they are highly concentrated and used so sparingly.

for touching up spots on color prints and transparencies (similar to the way black spotting dye is used for black-and-white prints; see page 12). The brilliant dye colors are much too strong to be used straight from the bottle, so dilute them with water.

Preparing and Cleaning Solutions

Two solutions are included in most photo oil kits, and both should be used sparingly. One is a mixture of turpentine and oil used for preparing the surface of rougher, matte papers—you can safely substitute a generic artists' oil medium. The other is an alcohol-based solution used for cleaning—you can substitute a small amount of rubbing alcohol. In this book, I will refer to them as "the oil solution" and "the alcohol solution."

Other Materials

You will also find the following extras invaluable: a *stick eraser* that can be sharpened to a point; a can of *compressed air* for removing dust and debris; *paper towels* and *rags* for blotting and cleaning; *artists' tape* or *drafting tape* (special low-tack tapes); and *spotting dye* to remove dust spots and blemishes (liquid spotting colors are the most common type and the easiest to use; you may need one bottle of neutral black and one of brown for sepia-toned prints).

TINTING WITH OTHER MEDIA

Most people think of photo tinting as "colorizing" vintage portraits with smooth, even applications of photo oils, but really, it's so much more. Any subject matter can be transformed, and a variety of media can be applied. You may be experienced with specific media and prefer to use ones you already know and enjoy. Or, you may simply want to experiment with the effects created by other media. Artist Bill Powell has had great success using watercolors, colored pencils, and oil pastels, in addition to colored markers (see pages 44–63). Just keep in mind that no matter what medium you use, it must adhere to the print, so you'll need to prepare your photos first (discussed on demonstration pages).

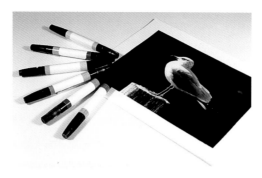

Colored Markers Bold, easy-to-use markers lend themselves to selective coloring and graphic accents.

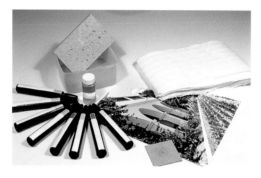

Photo Markers With the ease of application of regular markers, but with archival quality, specially formulated markers actually penetrate the photo surface.

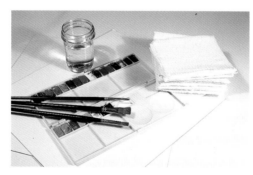

Watercolors You can mix many custom colors from a small set like this.

Colored Markers

Two different types of markers can be used successfully for tinting prints. Ordinary felt-tip markers are available in a great variety of colors. For print coloring purposes, it is best to buy ones that have a blunt, flat tip on one end and a sharp point on the other. SpotPen™ hand-coloring markers are made specifically for coloring photos and are available individually and in sets at photo supply and art and craft stores.

Watercolors

Watercolor makes a wonderful coloring agent because it can be made so transparent. Watercolor paints can be purchased in cakes or single tubes (I prefer tubes), but for convenience, you might prefer buying a complete watercolor set. These are available at art supply stores in a variety of sizes, from large sets with deep wells for mixing to small, compact kits.

To apply watercolor to your print, you will need several soft-bristled brushes, both flat and round. You will also need paper towels and an assortment of small jars for water. And because these paints are water-based, they will not adhere easily to untreated prints; apply acrylic flow medium or flow enhancer to your print before tinting.

Colored Pencils

Colored pencils are available separately or in sets, but start with a set of at least a dozen colors. Also, be sure to buy pencils

Colored Pencils Their color won't stick to glossy photos, but used on matte finishes, the look is unique—more like a drawing than a photo.

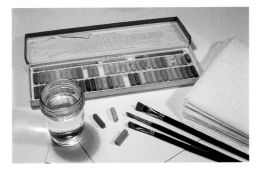

Oil Pastels A strong stroking pattern is oil pastel's charm. Turn a photo into a painting with oil pastel's textural effects.

that have fairly soft leads. The wax in soft leads allows for better blending and won't damage the photo surface as easily as harder-leaded pencils will. Blending colors is a constant process with pencils, so you will need several soft-bristled brushes, soft blending cloths, and paper stumps (tortillons). You can also blend colored pencils effectively with turpentine or odorless art thinner. Finally, you will need to have on hand a supply of paper towels, a kneaded eraser, and a good pencil sharpener.

Oil Pastels

Oil pastels come in sticks or crayons, and they are also available separately or in sets. (Be sure to use oil pastels; the soft, chalky type of pastels do not work for photo tinting.) As with colored pencils, start with a small set and add individual sticks when necessary. You will also need paper towels, as well as several soft-bristled brushes and a small jar of turpentine or odorless thinner for blending.

Selecting the Right Photographic Paper

Choosing the right paper on which to print your photograph can contribute greatly to a successful image. You want enough surface texture to hold the paint or coloring medium, but not so much that you can't apply color smoothly.

The three standard photo finishes are glossy, matte, and semi-matte. Glossy paper has a smooth, reflective surface that doesn't hold paint well and is usually not suitable for coloring. Matte paper has a dull, rough surface and holds the most paint, allowing for deep, rich colors. It is the best choice if you want to use watercolors, pencils, or other alternatives to oil colors. Semi-matte—also called luster, pearl, or satin—has a slightly textured surface. Its smoother surface makes it a good all-around choice for photo tinting, allowing for both deep and pale coloring. Specialty papers, such as linen or canvas, have a more textured surface and may be just the thing to complement your style.

You can choose between resin-coated (RC) and fiber-based papers. I prefer to use RC paper, which is protected by a thin, plastic coating—chemicals won't soak into the paper when processing, so it can be rinsed off in five minutes and will usually dry flat. Fiber-based paper has no coating, so the chemicals sink into the paper—it takes longer to process and rinse, and it can curl when it dries.

Choosing the Proper Film

You will, of course, want to use black-and-white film for photo tinting. If you process your own film, you know that good negatives are a result of the right combination of film and developer. Many photographers spend a great deal of time experimenting with different combinations until they find one that is just right.

What to Ask For

If you don't do your own processing, ask your lab what kind of film it is set up for, and stick to that type. The chemistry for processing color film is completely different than that for black-and-white, and most small labs are equipped to do only color. One way around this problem is to ask your dealer for "cromogenic" film. This is a special film that gives you black-and-white negatives but can be processed in standard color chemistry, also known as "C-41 process." Cromogenic films have a very fine grain and tend to be forgiving of both over- and underexposures, and many professionals use these films exclusively. You can take this type of film to any one-hour lab that processes color print film, but they will use paper made for color prints, so your prints may have a brown or purple cast to them. If you think of these photos as proofs rather than as final prints, you can choose the ones you like the best and have them enlarged on black-and-white paper later.

Infrared Film

Infrared film is the film of choice for many colorists. It gives the photo image an ethereal, otherworldly look. Skies will be much darker and foliage will be lighter compared to results from regular black-and-white film. If there is a lot of green foliage in your photo, the print may be too dark to color; infrared film will render it much lighter, sometimes almost white, making it much easier to color.

Black-and-White Print This is an untouched infrared print.

Infrared film also works best under a strong midday sun, a time when regular black-and-white film is at its worst.

If you want to use infrared film, you must have a camera that can be focused manually, and you must shoot through a dark red filter to get the infrared effect. Be sure to read and follow exactly the instructions packaged with the film.

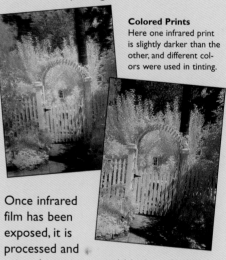

Colored Prints Here one infrared print is slightly darker than the other, and different colors were used in tinting.

Once infrared film has been exposed, it is processed and printed just as normal black-and-white film is. True infrared film is inherently grainy; accept the grain as part of its "look." Although this film can be a bit more complicated to work with, the results can be quite extraordinary, and I encourage you to try it at least once.

Picking a Photograph

To achieve a good end result, you must start with a good photograph. Aesthetic reasons for choosing prints are subjective, but there are some technical criteria to consider as well. First, prints should be large enough to work on—I suggest 8" x 10" prints to start. (Larger prints require more details.) Also, avoid prints with too much contrast. Photo oils don't show well when applied over very dark areas, and they look unrealistic and pasty when applied over pure white. A print with predominantly middle to light gray tones will work the best. And, when choosing a portrait, remember that proper skin tones are the most important consideration.

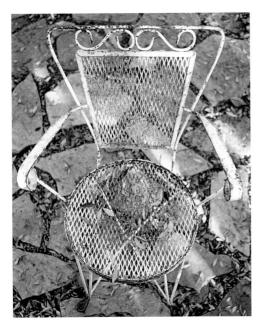 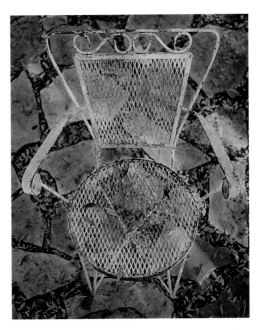

Enhancing a Dull Print This photo of a chair was in my reject pile for about five years. I liked the composition, but the chair didn't stand out from the background until I tinted it. Often two very different colors, such as red and green, will become almost the exact shade of gray in a black-and-white print. Adding color brought this print back to life.

Tinting Enlivens

Adding color won't make up for bad composition, nor can it make an out-of-focus print look sharper. However, there is one instance where color may improve a mediocre print: when a print looks dull because the tones of the subject are the same as the tones of the background. Also, keep in mind that many photos simply look better in black-and-white or with a sepia tone. And, whatever negative you use, it's a good idea to have several copies printed slightly lighter and darker so you can test the way each takes the color differently.

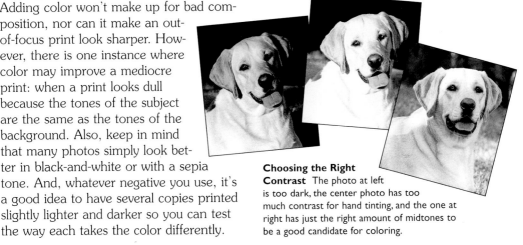

Choosing the Right Contrast The photo at left is too dark, the center photo has too much contrast for hand tinting, and the one at right has just the right amount of midtones to be a good candidate for coloring.

Sepia Toning

Before coloring your photo, you might want to tone it an overall sepia color (golden brown) first. Sepia toning provides two unique advantages. First, it warms up the base color of the print, which is particularly good for coloring portraits. Second, because it is not just a dye but a chemical process, it actually increases the stability of the print and guards against fading. In fact, for this reason, many photographers tone prints for archival purposes.

You don't need a darkroom to sepia tone; all the steps are conducted under normal light. However, you will need a sepia-toning chemical kit, two or three non-metallic trays, bottles in which to store the working solutions, print tongs, funnels, and a thermometer. Most sepia-toning kits use a two-step process (bleach bath and toning bath), but there are also a few one-step kits; all are available in liquid or powder forms. Remember: The bleach and toner chemicals should never touch one another, so be sure to use separate tongs and funnels for each.

Some sepia-toning brands will cause the toned print to be lighter than the untoned version. Therefore, you might have to develop the print a bit darker to compensate. If you have never toned a print before or if you've changed brands of toner, test the product first by sepia toning several scrap prints.

Neutral-Toned Paper The type of paper you use will greatly affect the color of the sepia-toned image. Both prints here were exposed and processed identically, and the bottom halves were sepia toned in the same brand of toner for the same amount of time. The photo above was printed on a neutral RC paper.

Warm-Toned Paper This photo was printed on warm-toned paper. Warm-toned papers change more dramatically when sepia toned than neutral papers do, and fiber papers change more than RC papers do. Compare the photo above with the one on the left, and notice the dramatic difference in color and skin tone.

Toning Procedure

Here is the basic method for sepia toning using a two-step (bleach and tone) process.

Step 1 Mix the chemicals—whether liquid or powder—according to the manufacturer's instructions, using distilled water. Immerse the print in a tray of the first bath, the bleach.

Step 2 Agitate the tray until the print fades away and only a straw-colored "ghost" of the image remains (2 to 5 minutes). Remove the print, and rinse it under running water (about 4 minutes for RC paper).

Step 3 Immerse the print in the second tray, the sepia-tone bath. Agitate the tray until the print reappears in its new brown color.

Step 4 Remove the print from the sepia bath, rinse it again in running water, and hang it or place it on screens to dry.

Caution!

As when using any chemical mixture, always follow the manufacturer's instructions exactly. I recommend using distilled rather than tap water when mixing to eliminate the pH and mineral content variables that might affect your results. Also note that sepia tones contain sulfur compounds, so most have a strong smell similar to that of rotten eggs. Use them only in a well-ventilated area, or even outside, if feasible. These chemicals are also toxic if ingested and should be kept away from children. If you have sensitive skin, wear rubber gloves and use tongs to handle the paper.

Using Spotting Dyes

Even the most carefully printed photos sometimes have small blemishes that will show through transparent paints if not removed. With a little practice, you can cover most light-colored blemishes by coloring them with spotting dyes (called "dust spotting"). Always check your print for spots before you start tinting. Spotting dyes are water-based, so they must be applied before you put any oil on the print.

Supplies You'll need black spotting dye (brown for sepia-toned prints), a palette, and a fine-point spotting brush. First put a single drop on your palette and let it dry overnight. (One drop will correct many prints, so you may want to work on several photos at a time.)

Step 1 Dip your brush in clean water, and then touch it to the dried spotting dye. Remove excess water and test for color intensity by making small strokes on a piece of plain, white paper. Getting the brush almost dry is the key to successful dust spotting.

Step 2 When you reach the shade of gray or brown that matches (or is a bit lighter than) the area around the dust spot, very lightly touch the brush to the spot. Use several light touches of the brush to fill in the spot, rather than one.

Step 3 To fill in longer scratches or marks, make a series of dots instead of trying to paint in a line. Practice on a scrap photo until you get the proper touch. The trick is to stop just before the light mark turns into a dark one.

NOTE: Fill in spots in the darkest areas first (when the brush has the most dye on it); then move to the lighter areas as the brush dries. If you do make any spot too dark, you may have to wash the entire print under running water to remove the dye.

Setting Up Your Work Area

You will need a well-lighted, comfortable, and roomy workspace for hand tinting photos. It's always best to work by natural light, if possible; if not, use bright incandescent lights. The light from fluorescent lamps is very cold (blue-green), making it hard to judge your colors, especially when you're tinting skin tones.

Working on a flat, perfectly smooth surface is essential. You will be rubbing over your prints, so any scratches, ridges, or dirt specks on the underlying surface will create dents in the photo. Glass, Plexiglas™, or smooth hardwood panels are good choices. You will also be spending several hours at a stretch at your work table, so a having comfortable chair is a must. Be sure to place a wastebasket nearby for disposing of used cotton swabs. And be careful when wearing long sleeves—oil paints can stain clothing, so you might want to wear an artist's smock. Finally, move your telephone to within arm's reach; it's almost certain to ring while you are working!

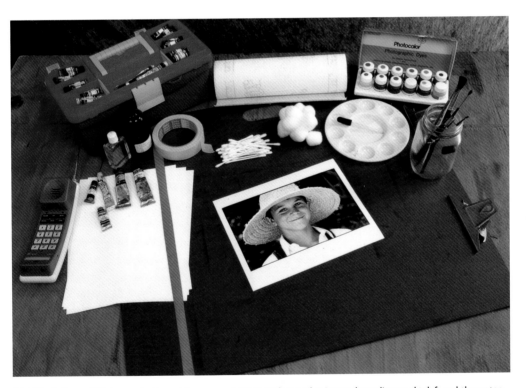

My Work Area This is a typical layout for my workspace, with my oil paints and supplies on the left and the water-based dyes on the right. The large (23" x 25") clipboard makes a nice, smooth work surface that can be turned as needed, and you can leave the print taped to it and turn it over or hang it up until the paints dry. This way dust and dirt won't fall on the print as it dries.

Mounting Your Photo

If you choose to color with artists' watercolors, regular felt-tip markers, or colored pencils, you may want to wet mount your photo first on a piece of firm illustration board. *(Do not do this when tinting with photo oils, dyes, SpotPen™ markers, and oil pastels.)* Wet mounting is a simple technique using a clear polymer glazing medium (available at art supply stores) to adhere the photo to the board and provide a protective coating. The coating prevents the photo surface from being marred by the coloring medium.

You may also have a precious photo you would like to tint, but you don't want to lose the original black-and-white print. You can color a photocopy of it instead, but you will want to wet mount it before coloring. Take the photo to your local copy shop, and request that your copy be made on their highest-quality color copier but in black and white only. The resolution will be better than that you can achieve from a self-copier, and the paper stock will be closer to that of a real photo. Then follow the steps below for mounting your copy.

Supplies You will need a flat work surface, clear polymer glazing medium, a soft-foam paint roller, a large dish or tray for soaking, a few paper towels, and a piece of firm illustration board cut slightly larger than your print or photocopy.

Step 1 Fill the dish or tray with enough water to submerge the print. Gently push the print in the water for 2 to 3 minutes, wetting it evenly. (Soaking for too long will weaken the paper and cause it to tear, so be alert.)

Step 2 Remove the print from the water bath, and place the wet print between two paper towels to absorb the excess water. Gently and evenly press the print between the towels so the water is absorbed evenly.

Step 3 Pour enough polymer glazing medium to fully cover the illustration board and spread the medium with the foam roller until you get a smooth, even texture. This coating will allow the photo to adhere to the board.

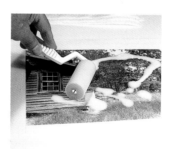

Step 4 Carefully position your photograph on the glazed board, and pour enough polymer onto the photo to overlap onto the board. Gently roll the medium over the photo and board until the surface is uniformly smooth.

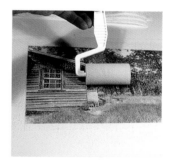

Step 5 Remove excess medium by rolling over several paper towels. Changing directions, alternate rolling over the photo and over the paper towels until the photo has the desired amount of surface texture. Set aside and allow to dry.

Getting Started

Taping Down the Photo

You'll probably want to tape your photo to your work surface to keep it from shifting as you color. (Use artists' or drafting tape; they aren't as sticky as masking tape, so they won't leave as much residue.) You can tape all the way around to create a clean border, or you can just tape down each corner and clean off the border area with the alcohol solutions when you're finished tinting.

Setting Up Your Colors

Now, looking at your print, decide which colors you will need and lay them out nearby. If you're using oils, squeeze out only a tiny amount of paint at one time; you can add more as you need it, but the paint may dry out if left in the open too long. (Sometimes the oil separates from the paint in the tube, so make sure you actually squeeze out paint, not just oil. You can stick a toothpick into the tube to mix the paint if needed.) At this point, you may need to thin the paint if you're using artists' oils or watercolors; photo oils don't need thinning.

Coloring

To avoid smudging the paint with your wrist or sleeve, it's best to start at the top corner of the photo (top left if you're right-handed, top right if you're left-handed) and move down and over. Cover the largest areas you want to tint first; then work your way down to the details, using light colors on lighter tones and dark colors on darker tones. Remember, much of the shading is already in the print, so one color will automatically take on different hues in different areas because of the underlying gray tones. However, no matter what paints you use, you can't make a very dark gray tone look bright yellow, nor turn a very light tone into navy blue.

Cropping Your Photo

In an ideal world, you would always have time to compose your shots, but in the real world, it's not always possible. For example, you may not have time to make a good composition, or there may be some physical barrier in the way. Or you may find something in a photo that you would like to focus on at the exclusion of everything else. This is where cropping comes in. For the photo at right, I could not get any closer to the water polo goalie, so I took my shot as best I could. By cropping distracting elements (in this case, the confusion in the background), I brought the focus squarely back to the goalie where it belonged and solved the compositional problem.

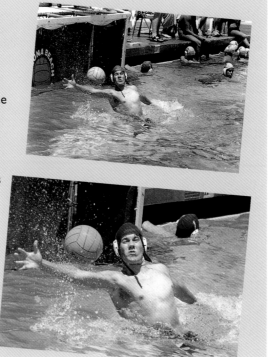

II. Oils and Dyes: Photo Oils
with Ed Krebs

Photo oils are my favorite coloring medium, but if you apply the oils to a bare print, the colors will grab the surface a little too strongly, especially if your photo is printed on matte or rough paper. Instead, it's a good idea to prepare, or *prime*, the photo first with a light coating of an oil-based solvent (which comes with many photo oil sets) or mineral spirits, which will help the colors go on smoothly. Dab a cotton ball with a small amount of the solution, and blot it on a paper towel. Then rub the photo surface uniformly back and forth and up and down until you can no longer see any sheen from the liquid. Be careful: Too much solution will keep the paint from sticking, and it will take longer for the colored print to dry. Now just follow the steps below to color your photo.

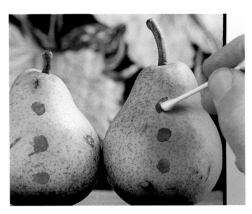

Step 1 After priming, the first step is to "rough in" the color in the general area you want to paint. With a cotton swab, dab small amounts of paint onto the print. Remember, a little bit of paint goes a long way, so don't go overboard. It is much easier to add more paint later, if necessary, than it is to take it away.

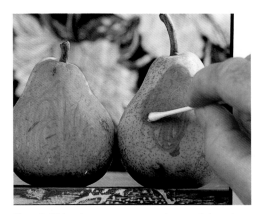

Step 2 Using the same cotton swab, spread the paint out to the edges of the designated area, gradually increasing the pressure, as if to drive the paint into the print surface. If you find that you have a lot of paint or oil on the print, switch to the clean end of the swab and continue rubbing.

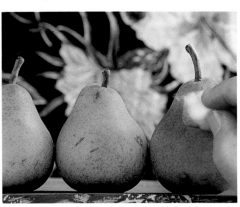

Step 3 Now gently buff the pears with a cotton ball, continually turning the cotton until the marks from the swab are gone and the paint is evenly spread out. (On a very large area, you may need to use more than one cotton ball.) The more you rub, the lighter the color will be. If you accidentally remove too much paint, go back to step 1 and add a little more color.

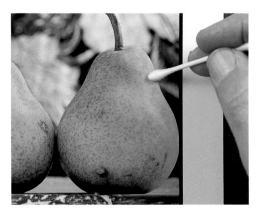

Repeat For each color you apply, repeat the three basic steps: dab on the color, spread it around the area by rubbing, and buff to blend the colors and smooth out the lines. Be careful not to rub the paint too hard when buffing, or you'll remove the underlying color. Here I'm adding the pear's highlights—an important detail for conveying depth.

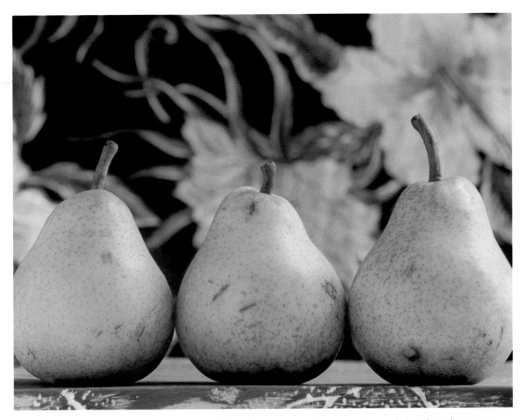

Final Tips Always save the swabs and cotton balls you have just used. If you need to go back and touch up a spot, you can use the swab that already has a little of the same color on it. This is the completed pear print after highlights and details have been colored. (For other ways to color these pears, see pages 56–57.)

Correcting Overpainted Areas

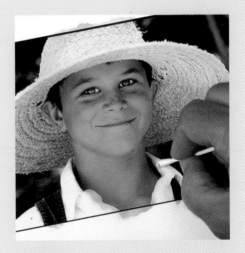

When you've finished buffing, you undoubtedly will find areas that you have overpainted and that you will want to correct. To clean small areas, simply touch a pointed eraser to the surface and lift off the paint. Wipe the eraser tip on a piece of paper and repeat as necessary. If the overpainted area is large, as it is here on the shirt collar and the top border, wipe it with a clean swab or cotton ball. If you are going to add another color to the area, you don't need to remove every bit of overpaint, since the new color will hide it. You can also dip the swab in alcohol solution, blot off the excess, and then rub the swab lightly across the overpainted area. Swabbing with alcohol may leave a sharp line, but a light buffing of the edges with a clean cotton ball will make them disappear.

Texture Tinting

For subjects with a lot of texture, such as wood, brick, or foliage, I like to use photos shot with infrared film, which is inherently grainy. Notice how the film's grain helps bring out the rough texture of the weathered siding in the photo shown here. I also sepia toned the print to make it warmer and strategically added color for more interest.

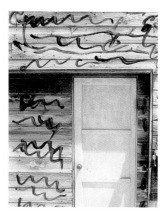

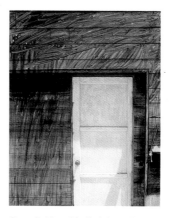

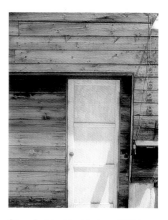

Step 1 First I applied dark brown for the wood siding, the element with the most texture (this is a larger area than the pears on page 16, so I scribbled on color instead of dabbing it on).

Step 2 Then I buffed the color by lightly stroking back and forth, following the grain of the wood. This way, if my buffing isn't perfectly even, it will simply add to the texture of the wood.

Step 3 Next I added small highlights of medium yellow to the boards to make them look more dimensional, blending very lightly so that not too much of the brown was removed.

Step 4 The door has a subtle texture, but I wanted it to really stand out, so I applied a bright phthalo blue, scribbling on the paint, and then buffed the color out.

Step 5 After buffing the blue, I added a tiny bit of crimson to the shadows on the door. This violet hue keeps the door from looking like a cardboard cutout.

Step 6 Finally I painted the yellow details using a pointed swab and added a bit of violet in the shadows and on the concrete in front of the door to pull up the texture in the cracked cement. To complete the picture, I carefully removed most of the brown paint from the hanging wire with a pointed eraser.

Creating Floral Flair

Closeup studies of flowers showing the folds and ridges of soft petals and crisp leaves lend themselves easily to photo tinting. This example is a fairly simple arrangement with one central lily and a background that does not compete with the flower. (I used a sheet of wallpaper from a discarded sample book for the background.) The lighting was soft, indirect, and augmented with a small foil reflector.

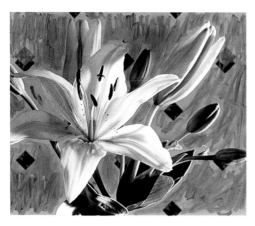

Step 1 First I tinted the background with crimson and a little blue, applied sparingly to keep the color light. This will keep the focus on the flower.

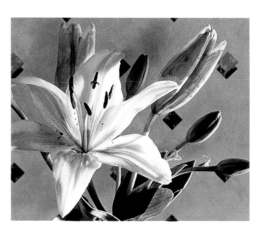

Step 2 Next I placed dark green on the unopened flower buds and stems, leaving the leaves at the bottom uncolored until later, to prevent smearing.

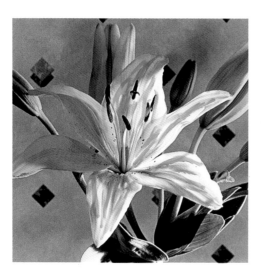

Step 3 I colored the main flower bright yellow and gently buffed it out. Be careful when using yellow—a little bit goes a long way, so it's easy to overcolor. Also, keep in mind that yellow will leave a milky haze when used over darker gray tones, so try to avoid that.

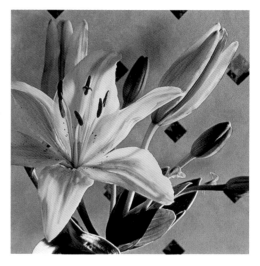

Step 4 For details, I applied a few stripes of orange to the petals of the main flower and to the highlighted edges of the buds. For the leaves at the bottom of the print, I used dark green with a bit of yellow on the highlighted edges, which makes the flowers stand out.

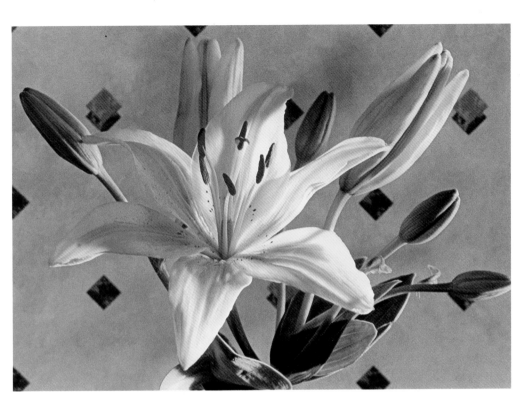

Step 5 Last I used basic red on the diamond shapes in the background. I don't remember exactly what colors were in the flower arrangement in real life, but it doesn't matter—flowers give you an opportunity to experiment with different color schemes.

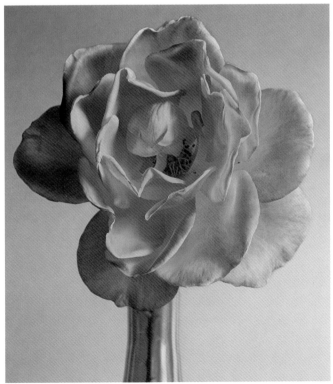

Another Approach The actual rose I photographed here was pale pink with a touch of yellow on the petal edges. I decided to use deeper, more robust hues for a dramatic look. The hand-tinted photo is not meant to be a replacement for color photography, so don't be afraid to get creative.

Emphasizing Contrasts

Here the free-form shadow cast by the palm tree is in sharp contrast to the right angles and balance of the rest of the composition. Adding color to the shadow and leaving the rest of the wall, park bench, and ground untouched further accentuated the contrast. (This technique of selective coloring of a black-and-white image has been used in print advertising and film to draw attention to one part of an image or scene—it works!) The image in this photo was so graphic that I decided a simple color scheme was all that was needed. However, a full-color version might also be interesting. Make several prints of an image so you can experiment with a few different versions.

Step 1 First I applied smudges of violet to the general shadow area on the wall. Then I spread the color along the frond shadows, buffing it out.

Step 2 After buffing the violet, I added dabs of red and more violet to intensify the color and make sure that the shadow would really pop off the white wall.

Step 3 Then I blended in the colors in the shadow and lightened areas of the white wall by cleaning off some color with a fresh swab. This further emphasized the contrast between the shadow and the wall.

Step 4 Next, to unify all the elements, I applied red and violet to the vases, complementing the color in the shadow, and touched in a little dark green on the potted plants.

Step 5 To finish, I used dark brown on the tree trunk and blue on the bench. Then I added blue to the tile border and yellow highlights on the tile pattern so it would really stand out against the shadow of the palm.

Basic Portrait Tinting

Although the tinting techniques are the same for any subject, portraits have some characteristics that take special consideration. For example, whereas outdoor scenes and still lifes can benefit from artistic interpretation, a face must look "correct," and the trickiest part is getting accurate skin tones. If you are using photo oils, look for a color named "Flesh No. 2": it produces the best results for most portraits. A bit of red can be added to create lighter, pinker tones, and dark brown can be mixed in for darker skin tones, although remember that the underlying shade of gray will already be darker. Also, most portraits benefit from an initial sepia toning; the added warmth makes it much easier to achieve realistic skin tones. To demonstrate tinting faces, I chose this straightforward portrait of a young boy with a simple background.

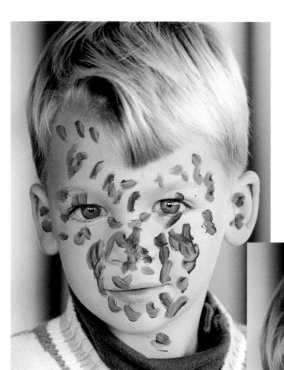

Step 1 Tinting with flesh tones is the same as coloring any photo. Here I started by applying small dots of paint around the center of the face using a cotton swab. Then I spread the paint over the face using a circular motion.

Step 2 When I spread the paint around the face, I made sure that I also applied the color into the boy's scalp and ears. At this stage, I color right over the eyes and lips (and the teeth as well, if they are showing); I will add blue to the eyes later.

Detail Notice the hard edge between the hair and face (known as "edge halo"). When buffing out hair, gently wiping back and forth across this hard line will make it disappear.

Step 3 After lightly buffing the flesh tone, I roughed in the hair color. (Raw sienna is a good choice for blond hair.) Then I buffed out the hair.

Step 4 Next I placed a tiny amount of red paint in the middle of the lips; then, with the other end of the swab, I spread it out a little. Using the same swab and without adding more paint, I lightly put a few dots of red on each cheek using an up-and-down motion. Stroking up and down prevents me from accidentally lifting up the underlying flesh color.

Step 5 To buff out the lips, I first used an up-and-down motion to tap the red color into the area. (It is important not to go out of the lines here, because it will be hard to clean up mistakes without destroying the underlying flesh color.) When the paint was fully spread out over the lips, I used a clean cotton ball, again with an up-and-down motion, to lightly remove the excess paint.

I used the same cotton ball to buff out the cheeks (but I do that only if there isn't too much paint on it). I dabbed both up and down and side to side slightly until there was no sharp definition to the red areas. The goal is to put a healthy glow on the cheeks, not to give the impression of makeup on the model. This technique takes some practice, but it is essential for doing good portrait work.

Next I began coloring the eyes by putting a minuscule amount of blue on the end of a pointed swab and dabbing it directly in the center of the eye.

Step 6 To complete the eye, I held the clean end of the swab perpendicular to the print and turned the swab alternately clockwise and counter-clockwise between my fingers to spread out the paint. If I find I have applied too much paint, I remove the excess by dabbing with a clean cotton ball. If I need more color, I add it in tiny amounts. It is much easier to add more color than to clean up overpainting!

When the eye was complete, I touched the end of an eraser to the white of the eye to remove some color. Then I cleaned the eraser tip and repeated until all the color was gone. This step is like magic—the picture really comes to life once the eyes are finished. (I use the same eraser technique to clean the teeth of any overpainting, if they are showing.)

Step 7 Here is the completed print. I have cleaned the eyes and put a hint of red and blue on the shirt and sweater. To give the hair dimension, I added a tiny amount of dark brown to the darker areas.

Deciding What to Tint First

The steps I've just shown are the basic techniques for tinting faces, and the order of the steps works for most photos. However, if you want to paint a background, do that first, along with any hats or other objects on or near the subject that appear near the top of the print. As with any tinting project, always try to complete an entire step or color an entire area in one sitting. If you think your first flesh tones are not deep enough, put a second layer on right away, before the first layer dries.

Testing Color Variations

It isn't always necessary to tint a photo to match reality. You can always alter what you see by trying various color schemes, and portraits are no exception as long as the colors are natural. Look at the three versions on this page as examples. Whatever colors you choose, pick a fairly simple pose for your first portrait, and make sure your subject is large enough to color easily. Each example below was tinted in just a few easy steps.

Untinted This is a good subject. The background and clothing are plain, and the features are large and simple.

Matching Reality Here I gave the subject dark brown hair, blue eyes, and pale blue shirt.

Changing the Colors This time I colored his hair and eyes light brown and made his shirt pink.

Making Subtle Changes Here I only altered the color of his shirt and lightened the tone of his hair.

Common Mistakes

Tinting with photo oils isn't difficult, but there are a few common errors that you'll want to avoid. Most of the common mistakes—no matter what the subject—involve applying too much paint. Below are some common overpainting errors and how to correct them.

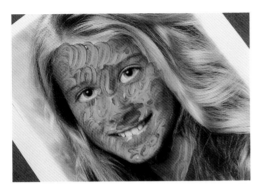

Too Much Here, Not Enough There This is an example of applying too much color on the face while failing to tone the eyes and teeth. You won't be able to spread the color evenly if you are trying to go around these features. Just rub the paint right over them and clean them out later. And remember that it takes longer to clean up too much paint than it does to add more color. You will buff out most of the color anyway, so there's no point in wasting paint.

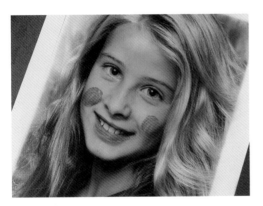

Wrong Way This example shows too much red on the lips and cheeks. You won't be able to blend enough to make the color look natural, and it's hard to remove the red without taking the flesh tones out too.

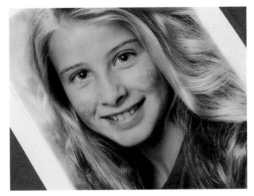

Right Way Use a tiny bit of red and apply it with a dabbing motion. Then it should be easy to blend it in with a cotton ball or swab. Don't worry about getting red on the teeth; you can clean it off in the next step.

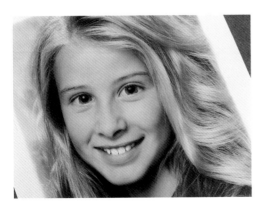

Wrong Way Beginners often put too much paint in the eyes or forget to clean out the highlights with an eraser. In fact, if the eyes are very small in your print, you might not even need to add color to them at all.

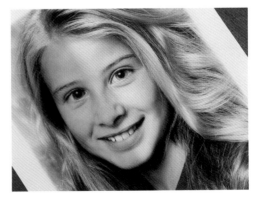

Right Way Rather than trying to buff out too much paint, just remove it and start over. If the paint is fresh, you can wipe it off. If it has dried, you will need to apply some turpentine or oil solution to soften the paint first.

Focusing on Details

This portrait has more detail than the previous examples, but the approach is the same: Start at the top and work your way down. Think in terms of planes, painting the background first, middle ground next, and foreground last. Although you should pay attention to details, don't spend a lot of time on things that can't be seen from more than 8 inches away. And remember, it's always easier to color details on a large-size print.

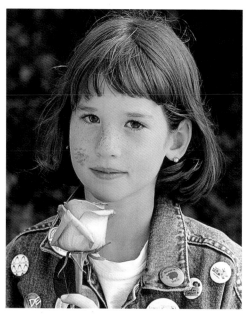

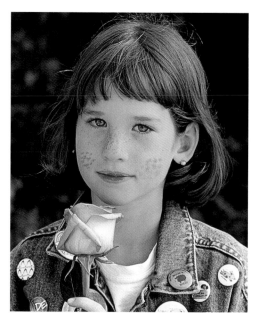

Step 1 After tinting and buffing out the face, I added dark brown, blended with a little raw sienna, to the hair. Next I roughed in the lips and cheeks with cheek red.

Step 2 After buffing the lips and cheeks, I roughed in the eyes with ultramarine blue and cleaned the white areas with the eraser, completing the face.

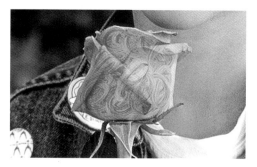

Detail I used three coats of rose madder on the rose and then added a coat of cheek red. To make it stand out even more, I finished with two more coats of red.

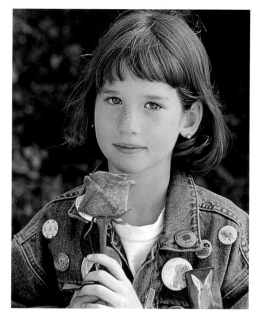

Step 3 Now I was ready to get to the details. I tinted the jacket blue and roughed in various colors on the buttons. Then I focused on the rose (see detail).

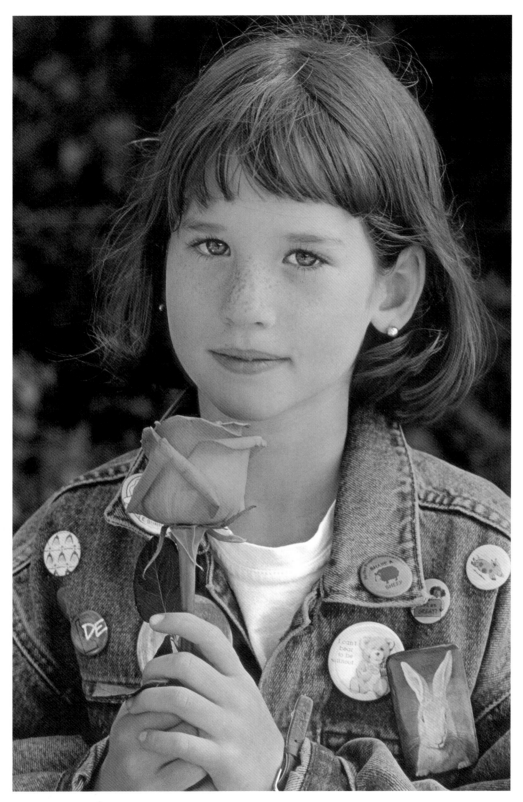

Step 4 I added final touches to the buttons, including the hint of pink on the rabbit's nose and ears. Then I cleaned up any overpainting, especially on the white T-shirt and the blue jacket, since I wanted the details on the buttons to stand out. To finish, I rubbed the fingernails lightly with a clean swab, being careful not to take off all the paint.

Subtle Shading

When I arrived for a photo session with these two brothers, I was immediately drawn to a shaded area in front of a wooden door. Don't be fooled into thinking that there isn't enough light in shaded areas. When you are standing in sunlight, the shaded area may appear dark, but it is actually the softest, most flattering light for faces. This lighting also created subtle cast shadows and shaded areas. To accentuate the soft lighting and to add warmth to the print, I sepia toned it before tinting it.

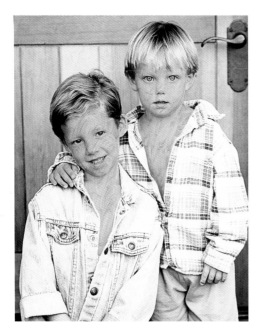

Step 1 I started this dual portrait by coloring in the flesh tones on the faces, chests, and hands first, then tinted the lips and cheeks with a cotton swab. Here I used slightly less paint than usual, partly because I already had a sepia-toned base, and partly because I wanted a soft effect.

Step 2 Switching to a toothpick, I added blue to the eyes of the boy on the right. The sepia toner and the flesh paint alone were fine for the other boy's brown eyes. After cleaning out highlights in the eyes with a pointed eraser, I roughed in the denim jacket with ultramarine blue and added color to both boys' hair.

Step 3 To complete the denim jacket, I buffed out most of the blue, letting the underlying photo provide the shading. Then I added a touch of brown over the seams to provide subtle depth. For the plaid shirt, I applied the base color, then lightly painted in different colors for the stripes. I didn't worry about following the lines precisely; I knew they would be blended when I buffed.

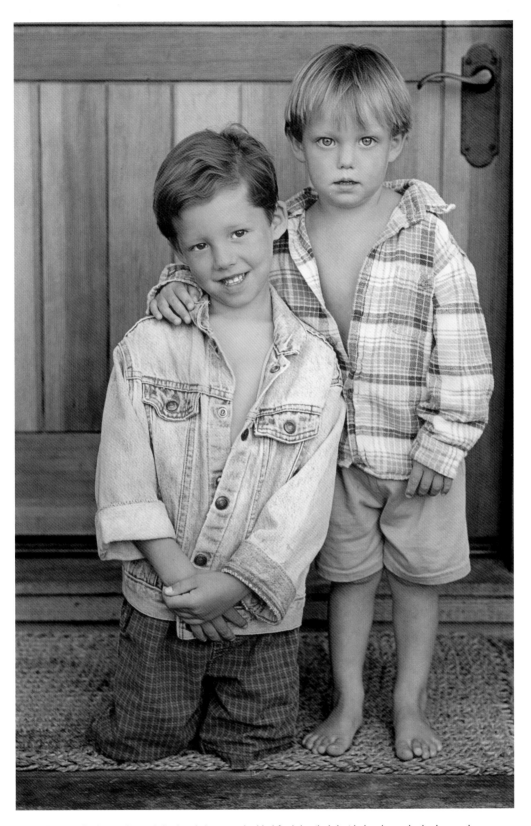

Step 4 In the final print, I tinted the boys' shorts and added final details. I decided to leave the background unpainted so the shadows weren't overworked and so the subjects would stand out more emphatically.

Enhancing Patterns

Patterned elements make a portrait a little more complex, but don't be overwhelmed by the detail. The underlying print will define the pattern; all you have to do is color it. I sepia toned and printed this photo at 10" x 12" to make the details easier to color, and, again, I decided to leave the background uncolored to help the subject stand out.

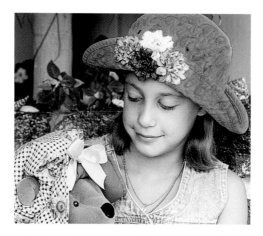 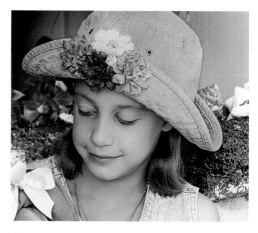

Step 1 Instead of starting with the flesh tones, this time I started at the top—with the hat. I began by roughing in ultramarine blue and spreading out the color. Then I roughed in a touch of violet over the blue. Adding the violet changed the hue just enough to distinguish the hat from the blue denim vest.

Step 2 The next step was to buff out the hat and paint the flowers, each with a different color: crimson, red, yellow, and orange. Once the hat was completed, I tinted the flesh tones in the girl's face and neck, painting over her necklace. Then I lightly colored her lips and hair.

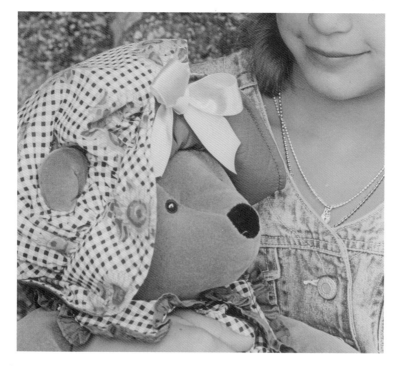

Step 3 Now I turned my attention to the stuffed bear—the next largest area to color and the one with the most pattern. I tinted the checkered hat and dress with dark green and then buffed vigorously to leave only a hint of color behind. Next I applied yellow and a spot of orange for the sunflowers printed on the clothing and painted the ribbon bright yellow to draw attention to the bear. For contrast, I colored the inside of the hat and the edge of ruffle on the bear's dress with violet and tinted the bear's fur with dark brown.

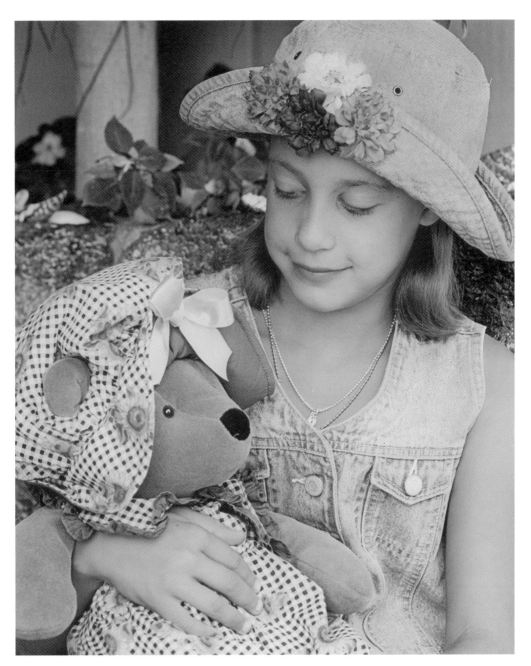

Step 4 Now all that is left is to add the finishing touches. To re-create the look of brass on the girl's vest buttons, I used both ultramarine blue and raw sienna. I painted the bear's nose and eye solid black and then used the tip of an eraser to pick out the highlight in the bear's shiny button eye. I used the tip of the eraser again to carefully lift out the flesh color from the girl's necklace. I was glad that I had decided to leave the background untouched. If I had painted that as well, the details and patterns would have competed with each other, and the picture would have lost a lot of its impact.

Developing Animal Portraits

Animal portraits are no different from people portraits. Soft, diffused light will allow more detail to show in the fur than will hard, strongly contrasted light. If you are taking your own photo outdoors in natural light, try to put your subject in open shade to tame the extremes between light and dark areas. Also, since there is usually no white showing in a dog's eyes, it is important to try to capture a "catch light," or a reflected highlight. But keep in mind that on-camera flashes often result in red-eye (or white-eye in black-and-white prints), which is difficult to tint out. Use an off-camera flash, if possible.

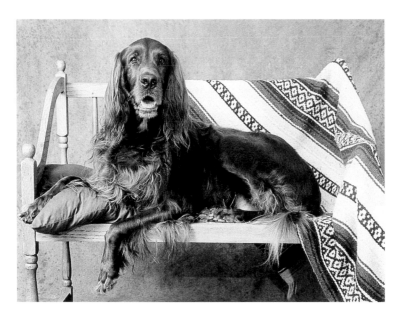

Setting the Pose If you can keep the pet in a confined area, as in this portrait of an Irish setter, you won't have to chase it around and worry about keeping it in focus. In this example, the camera was on a tripod, focused, and centered on the bench before I put the dog in place. As long as the setter stayed on the bench, I knew the photo would be in focus.

Step 1 For this portrait, I wanted a colored background, so that is where I began. To make sure the rust-red color of the dog stood out, I chose blue and violet for the backdrop, and then I painted the bench with raw sienna.

Step 2 I tinted the pillow with a simple carmine red, but it took several tries to come up with the right color for the dog's auburn coat. I finally settled on a combination of Van Dyke brown mixed with a little carmine red and orange.

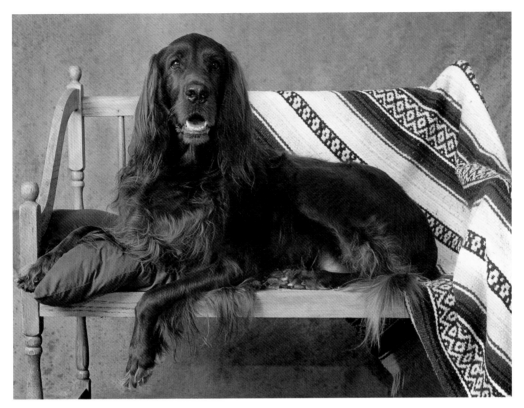

Step 3 To finish, I added a little color to the blanket, tinted the dog's tongue red, and cleaned the overpaint on the teeth with an eraser. Notice how the repetition of colors brings the subject into harmony with its setting.

A Different Approach

You don't need a subject with as vibrant a color as an Irish Setter. Even this little tan and white Corgi makes an appealing subject for photo tinting. Subtle touches of pink on the insides of the ears and gold for highlights in the light brown fur make an understated pet portrait. But who says you have to be subtle—or tint with realistic color either? Unless you are doing a commissioned portrait for a proud pet owner, you don't. Take a look at the Easter puppies on page 51! That's the beauty of photo tinting: the choice is all yours.

Intensifying and Changing Colors

It may initially appear to be an odd choice for photo tinting, but a silhouette presents many possibilities for interesting background color and can produce dramatic results. To create a silhouette, I exposed for the background and allowed the figure in the foreground to go completely black. Then I printed it on paper that eliminated all the details in the figure and also brought out the clouds—the part of the print I wanted to color.

Step 1 My first step (left) was to apply violet to the darkest areas of the clouds and then buff the color out.

Step 2 Next (right) I roughed in dark yellow on the lighter areas of the clouds.

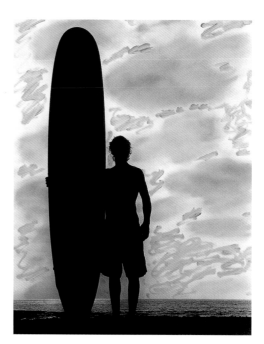

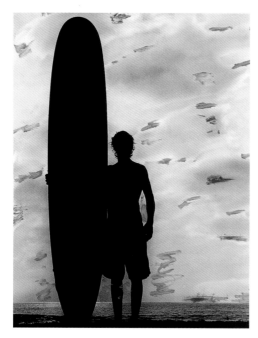

Step 3 Here I added orange and crimson. Since there is no real definition of boundaries in a subject such as this, I had to guess somewhat about where to put my colors. Then I buffed the sky well to blur the lines between colors.

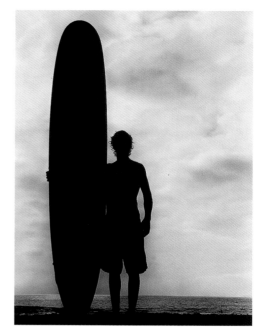

Step 4 The sky is a fairly large area to cover, so I used a clean cotton ball to lightly buff the whole area with a back-and-forth motion.

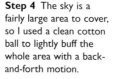

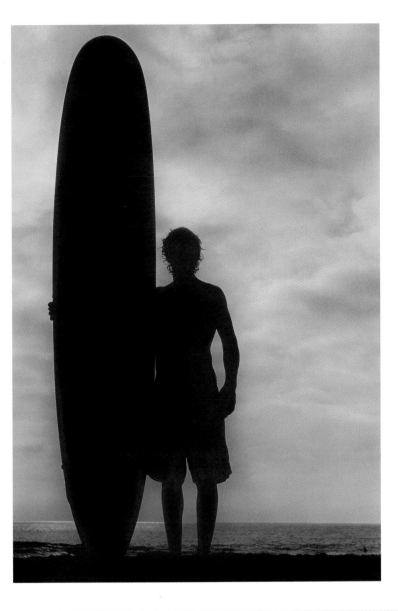

Step 5 When I had finished, I decided that I wanted more intensity in tone, so I added more of the same colors right over the top. One of the main advantages of tinting with oil paint is that it's easy to redo! After painting over the photo, I still wasn't happy with the result. Again, without first removing any of the underlying paint, I colored over it all with orange and used only a little yellow and violet, letting the orange dominate. Notice that adding color over a previous layer gave the finished product more depth.

Cleaning Off Color

During buffing, some of the color may be carried onto the solid black of the silhouette. When that happens, carefully clean it off with either the oil or the alcohol solution; otherwise, a milky haze will show when the print is held at an angle to the light.

Most oil-based colors are easy to remove. However, be aware that certain colors, such as the reds and violets, have more staining power than others and may prove impossible to remove completely.

Tinting with Retouching Dyes

Advantages of Water-Based Dyes

There are two excellent reasons for using retouching dyes: (1) for detail work and (2) for their brilliant color. Unlike photo oils, dyes can be applied with a fine brush, which makes them excellent for painting small details. Also, the actual colors of dyes have a different quality than oils, and you can achieve spectacular results if you take time to build up colors. Dyes are also fairly versatile. You can use them on both fiber-based and RC papers. If you are using fiber papers, keep them damp while you are working; RC papers should be kept dry.

Using Dyes with Oils

The usual method of tinting a photo is to start with large areas and work your way down to the fine details. However, if you

Getting Ready Use an eyedropper to extract one or two drops of dye from the bottle, and place them in a well on your palette. Dilute the color with at least three or four drops of water for one drop of dye; then test the color on a piece of scrap paper to see if it needs more diluting. A drop or two of a wetting agent, such as Photo-Flo (available at photo supply stores), can be added to the water to make the dyes spread more smoothly. (Be sure to rinse the dropper after each color so the next color is not contaminated.)

want to use water-based dyes on the same print as oil colors, you must apply the dyes first (remember, water won't adhere to oil); therefore, you must do the opposite and start with the details. After painting the details, let the water in the dyes dry for a short time and then apply the oils on top. Since dyes soak into the photo's emulsion, they won't come off when you buff the oil paint or even when you use an eraser. This means that you can buff out and clean up a larger area without destroying the color in the details. But it also means that removing mistakes and spills (and dyes do run and bleed) may prove difficult. Even if you wash the entire print under running water, all the color may not come out.

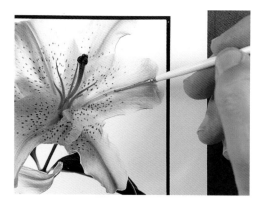

Dye the Details Here I am applying dye to tiny details in a lily with a fine (5-0) spotting brush. Keep a paper towel in one hand and blot the print frequently as you apply the dye.

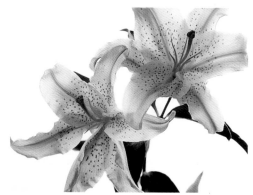

Apply Oils Over Dyes In this photo, oil color was applied shortly after the water-based dyes had dried. Notice how the dye colors show through the transparent oils.

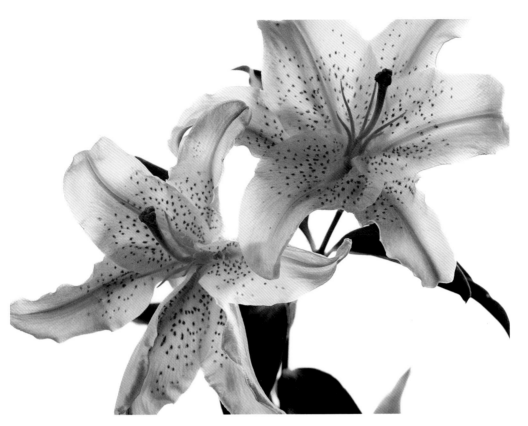

Changing Colors This is the completed lily print, showing a combination of oil color and water-based dyes. I took the first coat of orange paint off with the oil solution, which had no effect on the underlying dyes. Then I applied a new layer of crimson red and buffed it to a light pink tint.

Applying Dyes

The basic technique for tinting with water-based dyes is to dip the brush into the diluted color and blot it on a piece of plain white paper. Then carefully apply the color to the print, keeping the brush moving at all times. (If you stop mid-stroke, your color will be spotty.) The amount of water you have on the brush makes a big difference in how the color is spread. For very tiny areas, the brush should be almost dry, and the dye should not be too thin. For somewhat larger areas, use a wetter brush; it will help spread the color more evenly. Very large areas can be covered with a swab instead of a brush, but the dye should be very

diluted; too strong a color will streak and you'll never achieve a smooth coloration. Because the dye solution is very weak, you'll need to slowly build up the color in layers to get bright, rich tints.

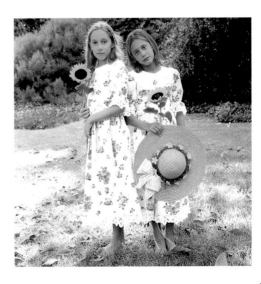

Suitable Subjects First I used dyes to color the sun-flowers and the flowers on the hat and dresses. Then I used photo oils for the skin, hair, and hat. Combining media makes perfect sense here—oils for realistic skin tones and dyes for brilliant color and fine details.

Coloring Vintage Prints

Almost everyone has a box of old family photos lying around. Some of them may already be hand tinted, but most are probably black and white or sepia colored. If you have some vintage prints that you want to color, always make copies of them first, so you can preserve the original prints intact. If you don't have the negatives for your vintage photos (as few people do), you can have copies made from the print itself.

Copying Prints

The time-honored method of making a copy of a print is to re-photograph it to get a new negative. Excellent copies can be made by using a large-format camera to get a 4" x 5" negative. Medium-format cameras can give you a 6-cm x 7-cm negative, which is also acceptable. However, 35-mm cameras produce such a small negative that the quality will suffer on anything larger than a 3" x 5" print. Trying to make a very large print from a

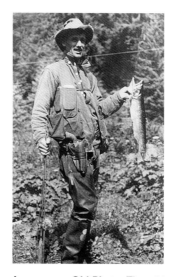
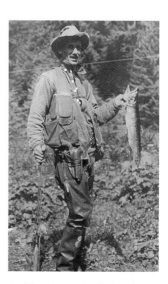

Improve an Old Photo The original print I found in a cabin had such low contrast that the figure and the background ran together. By copying it and adding color, I made the man and his prize catch much more distinct.

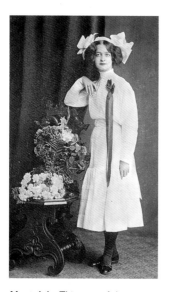

Nostalgia This turn-of-the-century beauty was frozen in sepia tones for nearly 100 years before I added some color. Dyes brought out the flowers and ribbon, and oil enhanced the face and dress.

small one is not usually successful unless the original is exceptionally sharp. Every blemish will be magnified, and anything out of focus will get even more blurred.

Once you have a good print, you might want to sepia tone it before tinting, especially for portraits. Sepia toning adds an "aged" look and gives you an overall neutral color base on which to apply your tints.

Copy Quality

The quality of your copy will depend on the quality of the original print. A

print that is in good physical shape, is sharply defined, and has been properly printed is easy to copy. A poor-quality print, or one that is damaged, will certainly not get any better during the copying process. If you have such a print and want to color it, seek out the services of a professional retoucher. Professional labs can repair damaged prints using computer technology. However, you must be certain that the lab knows that you want the finished print developed on real silver-gelatin photo paper so that it will be suitable for tinting.

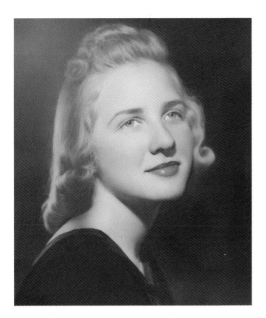

Photo Tinting Lasts The colors of this glamorous portrait are as vibrant today as they were when they were laid down in the late 1920s.

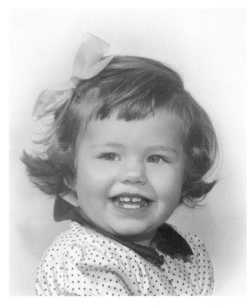

Color Adds Life Portraits of young children are especially suitable for tinting. The subtle coloration adds softness to black-and-white prints.

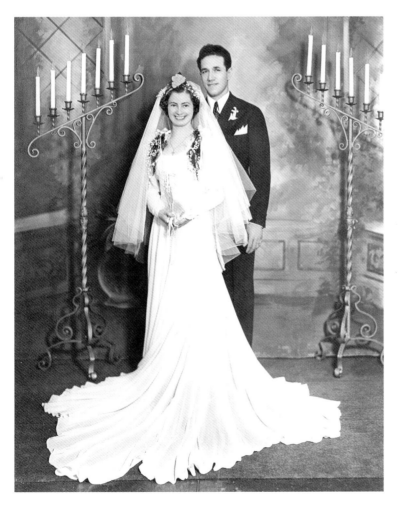

Enhance Memories with Color This photo was copied from an 8″ x 10″ vintage print on medium-format film. The new copy was printed just dark enough to keep some detail in the white wedding dress and then sepia toned to get the look of the original print. I tinted the candlesticks, candle flames, and a few small details, such as the woman's lips, with watercolor dyes so I could use a fine brush. The rest of the colors are oils. I often add a hint of violet in the shadow areas of white clothing, as in the bottom of the wedding dress, to add dimension. Since the couple's clothing is all black and white, subtlety must be used to keep the background color from detracting from the main sujects—the bride and groom.

III. Other Media: Photo-Coloring Markers
with William F. Powell

Now that you have seen how to photo tint using photo oils and water-based dyes, I would like to show you some alternative ways to color photos. The results may not look exactly like Ed's, but sometimes you just want to experiment and have fun with different media.

The first medium I'd like to demonstrate is photo-coloring markers. These markers come in a wide array of colors with both broad points for large areas and finer tips for detail (the markers I used are made by SpotPen™). Sets also include a bottle of flow/wetting solution, a color-remover pen, and a sea sponge for wetting the print. To demonstrate the basic technique, I am using a matte-finished photo of the San Luis Rey Mission in California. Of course, the techniques used here can be used on any photo you may have. Just be sure the photo surface is untreated—no glazing. The markers contain a dye that penetrates the surface, staining the print, so the only treatment your photo needs is the wetting solution provided with the pens.

Step 1 Before using the markers for the first time, I scrubbed the tips on a piece of cardboard to loosen the fibers. This protects the photo surface against scratches and allows the color to flow more smoothly. Then I mounted the photo on a firm board with drafting tape along the edges to keep the border clean.

Step 2 Next I gently moistened the area to be colored using the wetting solution and a damp-dry sponge. The solution softens the photo surface and allows the color to be absorbed. Too much moisture prevents the color from flowing smoothly, however, so I blotted any excess solution with a paper towel.

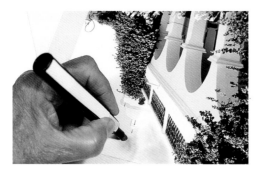

Step 3 For this landscape, I began by coloring in the background, applying light blue to the sky using small, circular strokes. I tried to make the color flow a bit unevenly in the sky to add more atmosphere, and I left the horizon lighter than the top.

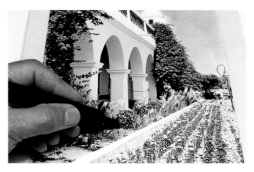

Step 4 Next I tinted the ground areas in the flower beds in a soft sand color. I chose a deeper sienna for the ground shadows and to add warmth, and I varied my strokes to suggest soil texture. Then I added some olive green in the shadows and flower bed for texture.

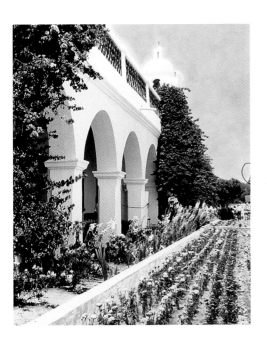

Step 5 Now I was ready to start coloring in the details in the foliage. I began by applying a warm yellow-green to the bushes and distant trees and a cool green on the flower stems and leaf blades, leaving the tops clean (where I would later add lighter green and yellow). I "spotted" in several shades of green into the foliage using light, tapping strokes to create an uneven pattern. Then I built up color to darken the areas under the boughs and bushes, and I added a bit of yellow in the ground of the flower bed to suggest sunlight, as shown in the detail below.

Step 6 To finish the foliage, I colored the gladiolus light pink, applied yellow and orange to the blossoms in the flower bed, and added a touch of rich red to the bougainvillea. Then I painted a slight shade of blue in the shadow areas behind the arches and placed a touch of tan on the bell. To complete the scene, I strengthened color where I felt it was necessary until I was satisfied with the result, which is always a matter of personal judgment and preference. Finally, I removed the tape and studied the scene, looking for any areas that might benefit from touches of additional color to deepen or intensify them. And here is the result: a landscape brought to life!

Tinting a Bridal Portrait

One sign of a good photo-coloring medium is how well it can do realistic skin colors. Here I used the same specially formulated hand-coloring markers on a friend's bridal photo with some very professional-looking results. This is not the kind of photo on which I would want to use "creative" coloring or have textural strokes showing. I also didn't want the background to compete with the bride, so I left it a sepia tone. By intensifying the colors on the bride herself and de-emphasizing every other aspect of the photo, the happiness of the event becomes the focus.

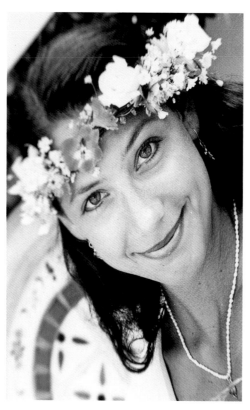

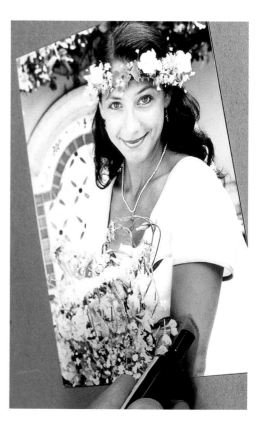

Step 1 I started by premoistening the flowered headpiece with the wetting solution, and then I tinted two flowers using bright blue, pink, and purple. These two sample flowers gave me a color reference against which to balance flesh tones, my paramount concern in this photo. If I had started with the flesh tones, I might have made them too pink, which might not have been noticeable until compared to the flowers.

Step 2 Now I was ready to tint the skin tones. I moistened the skin areas with the wetting solution and a damp-dry sponge. Then I selected a light tan marker with a broad tip so I could color the flesh tones with a minimum number of strokes. When applying color to areas such as the face and arms, make the strokes follow the surface shapes and directions—curved strokes over round forms and straight ones for angular planes.

Artist's Tip
Photo-coloring markers and pens work on RC, fiber base, glossy, and matte surface photos, but I had the best results with matte surfaces.

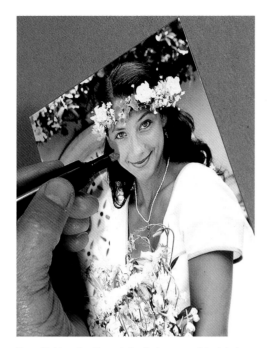

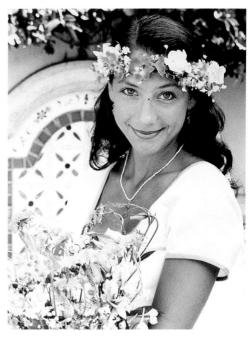

Step 3 Next I enlivened the flesh tones with pink. I deepened the pink on the cheek areas and added pale pink tones in the lighter areas and stronger pink tones in the shadows. This is the point where I assess the colors. If any stands out too strongly, I weaken it by using the color-remover pen.

Step 4 Here I tinted a variation of undercolors on the flowers, merely suggesting them with a soft pattern of strokes and dots using pinks, blues, and purples. I colored the leaves with warm yellow-green and accented them with a few spots of brighter green. Then I tinted the eyes with light blue.

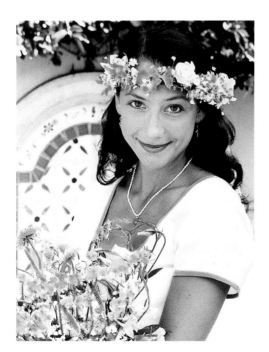

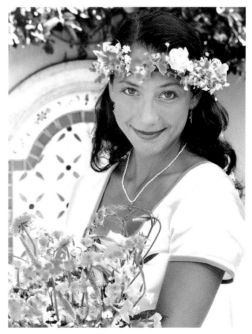

Step 5 I tinted the hair using warm brown (if it seems too warm, I shade it slightly with light blue). I lightly colored the lips using both a medium and a warm red. Lighting generally makes the upper lip appear a bit darker than the lower lip, so I tinted them that way.

Step 6 Here I painted a soft, light purple into the shadow areas of the dress, making the color a bit stronger in the deepest part of the folds. I also added some blush to the cheeks to make the image stronger so the focus would be on the bride's face.

47

Selective Coloring

Tinting only a few objects in a scene can be very effective. For this wedding portrait, I experimented by painting only the sky, ocean, and foliage in the background with the coloring markers, leaving the couple in the light sepia tone—the opposite of the more common method of tinting the people and leaving the background untouched. The day and setting were glorious, but if they weren't, I could always "beautify" them with color!

Step 1 I began by premoistening the sky area with the wetting solution, blotting any excess moisture with a paper towel. Then I started tinting the sky using a light blue marker with a broad tip, taking care to leave the clouds clean white.

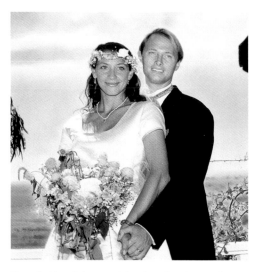

Step 2 Next I deepened the sky values here and there with several applications of blue, letting the color fade at the bottom to give a hazy effect. I painted the water with blues and greens, keeping the tints lighter toward the horizon.

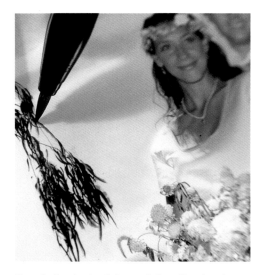

Step 3 For the detailed areas, I chose fine-tipped markers. I painted yellow-green on the tree leaves in the upper left corner. To overcome the darks, I allowed some green to overlap slightly into the sky, which also softened the effect.

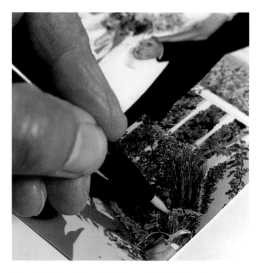

Step 4 Here I tinted the lower bush foliage with warm yellow-green and the twigs and branches with light tan and brown. Then I added a light orange on the flowers in the lower right and tinted the floor a warm beige accented with yellow.

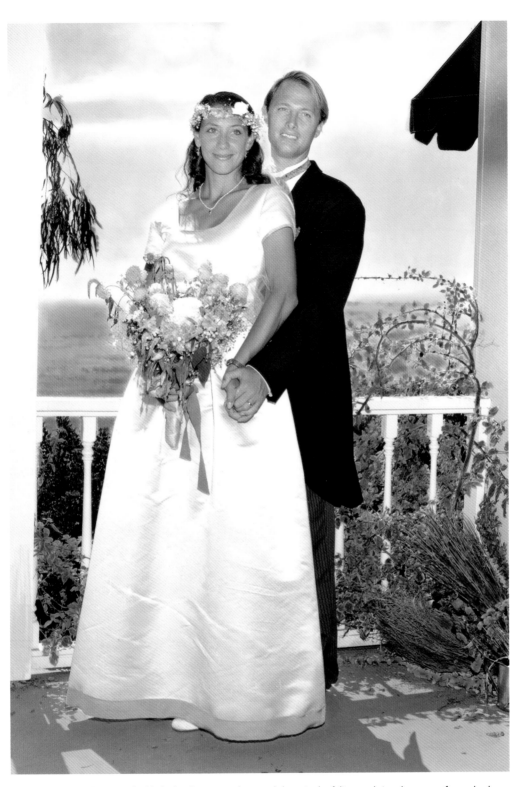

Step 5 To finish the photo, I added a brighter green here and there in the foliage and tinted a very soft purple glaze in the cast shadow below the bride and near the rail. I could have added darker tints to the background, but I wanted a strong contrast between the colored areas and the sepia-toned couple.

Using Artistic License

There is no rule that says you must use realistic colors when tinting photos. And if there were, I would ignore it and be creative! Here I unleashed my imagination while tinting a photo Ed Krebs took of two retriever puppies. In this project I used the photo-coloring markers. The basket made me think of Easter, and pretty soon it had evolved into "Pastel Pups." How about a Christmas motif using a photograph of your own pet as a greeting card? Or turning a person into an extraterrestrial by tinting the skin green and purple, giving a white cat polka dots, and truly making a "horse of a different color"? The colors you choose can be futuristic, fantastic, or fun—or all three.

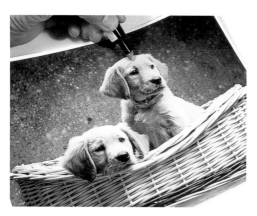

Step 1 I premoistened the pup on the right, then began tinting with light pink. I made circular strokes for smooth blends and allowed other strokes to follow the direction of the hair for texture, leaving highlighted areas lighter.

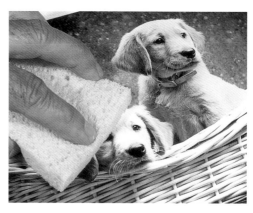

Step 2 Next I premoistened and tinted the second pup with light blue, leaving the whiskers white. If the colors overlap into areas you want to keep lighter, use the color-remover pen to pull out lighter spots and blot with paper towels.

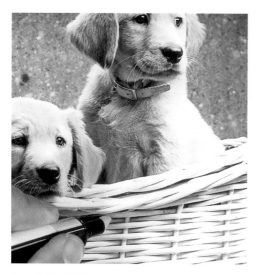

Step 3 Using broad strokes, I followed the direction of the wicker pattern and tinted the basket light yellow. To enhance the color in the deeper shadow areas, I used yellow, light tan, and medium tan detail pens. I applied medium tan to the shadows on each horizontal reed.

Step 4 Detail pens were invaluable here, because their fine points are able to reach into very tight areas. Here I used a tan marker to put warm color into the shadow areas of the the basket, and I used a red marker for the dark accent stripe.

Step 5 Then, using the pink and blue pens, I built up darks for the shadow areas of the pups and accented their features and expressions, always following the direction of hair growth. Whenever I needed to soften the effect or remove excess moisture, I blotted with paper towels.

Step 6 Here I used a blue-purple to lightly accent both dogs. I deepened pinks and blues where necessary and accented the bottom of the pink puppy using a bluish purple. Next I dabbed a bit of yellow for highlights on each dog and "spotted" pink on the blue pup's head, ears, and nose.

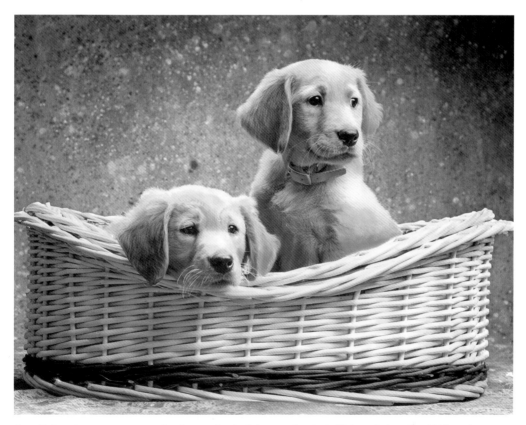

Step 7 I used a strong, warm tan for the eyes, leaving light areas for the highlights, which really add life to the eyes. Then I colored the collar green. So here it is—the finished "Pastel Pups!" Of course you could go on with more variations of color and really make it jazzy. Please yourself, but most of all, have fun with it!

Tinting with Art Markers

If you are coloring a matte-finished photo, regular felt-tip markers will work without any preparation of the photo surface. You can also color copies of prints. If you are using a laser copy print or an ink-jet print of an original photo, the surface must be protected against all the moisture in regular felt-tip markers. In such a case, a light but thorough spray-coating of workable fixative will preserve and protect the surface. For the example here, rather than covering the entire image with color, I added only touches here and there to retain the photographic look.

Step 1 This picture of a gull was an ink-jet copy print. To prepare it for art markers, I first mounted the print to a firm illustration board (see page 14) and then sprayed it with a workable fixative.

Step 2 I began with a yellow marker for the gull's bill, eye, and legs and for the wharf piling. Then I applied a warm ochre to the piling and the bird's underside and added a bit on the back of its head and bill.

Artist's Tip

You can use a self-service copier at the local copy shop for practice copies, but for quality reproductions, request that copies of your photo be made on the store's highest quality color copier but in black-and-white. The resolution and grayscale will be far superior to that of the self-help machines.

Step 3 Next I used a deeper sienna to color the pier post. I also added a tiny touch of the same color on the deeper parts of the gull's legs and underside and then applied small dots on the textured portion of the back of the gull's head.

Step 5 I continued to build up the blues, ochres, and siennas to the desired tones, trying not to make them too dark. Then I dabbed on a deeper brown tone on the back of the gull's head and on the piling. This is the stage where I assess the results and then deepen or lighten the tones to suit my own tastes.

Step 4 I used a light blue marker for the shadow portions of the gull, also adding small amounts here and there to create shading on the piling. Then I picked up the sienna marker again and slightly darkened the back of the gull's head.

Transforming the Ordinary with Watercolor

One of my ongoing artistic goals is to transform the ordinary into the extraordinary. This old homestead is the kind of scene you might look at a thousand times without taking notice, but coloring the photo brings the place to life. For this photo, I will demonstrate tinting with watercolor. First I prepared my photo for tinting following the wet-mounting technique and using a clear acrylic polymer solution (see page 14). When tinting with watercolor, always be certain to make the final surface as smooth as possible, because the color will pool around bumps and fill depressions. Once dry, I masked the sides with tape. (Rub the tape on your arm or clothing first to weaken the adhesive power. This will eliminate the possibility of tearing the photo while still giving enough adhesion to make a clean edge.) Now the photo is ready for watercolor.

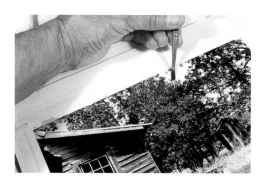

Step 1 I began painting the sky using a fairly weak mixture of phthalocyanine blue and acrylic flow medium (see page 6), dabbing it into the sky and lightly covering the distant trees. This creates a hazy, atmospheric effect. Then I added more water and flow medium to the color to make it even lighter for the horizon.

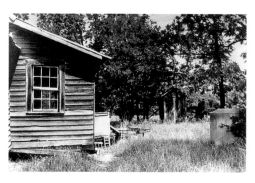

Step 2 I deepened the high sky a bit by adding a touch of ultramarine blue to the mix, but I kept the horizon lighter in value. With my brush loaded with a mixture of gamboge and a dot of phthalocyanine blue, I applied the color with a tapping stroke to create a texture on the distant trees.

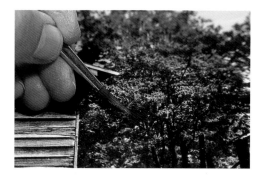

Step 3 Again using tapping strokes, but this time with Hooker's green deep, I darkened the foliage, allowing the color to overlap the sky edge slightly here and there. This adds softness to the trees and a suggestion of color to the deeper values. (Remember that the color won't show as well on a dark print, so you may want to choose a slightly underexposed photo.)

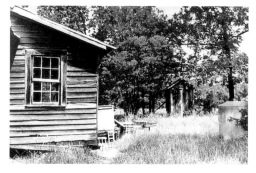

Step 4 With the very tip of the brush loaded with yellow ochre and sap green, I tapped in sunlit foliage on the trees. I added more yellow ochre to accent the lightest areas of the trees, and I warmed the greens in the foreground tree using yellow ochre and sap green. Then I added a bit of cadmium yellow light to the ochre as a final highlight on the sunlit boughs.

Step 5 For the grassy area, I painted in a wash of burnt sienna first and then used flat, stamping strokes to create the illusion of texture and to vary the color depth. I dotted lemon yellow in the backfield and burnt sienna and cadmium yellow light in the sunny foreground areas. Then I wiped away the color here and there with a paper towel to allow the light of the photo shine through.

Step 6 Last I painted a mix of burnt umber and permanent rose on selected boards of the buildings. I made a variety of blue-green colors by mixing cerulean blue and sap green and dabbed it on the dusty glass to indicate the tree reflections. Then I slowly and carefully removed the tape to reveal a clean, white border.

Directional Stroking with Colored Pencils

Do these pears look familiar? Ed Krebs showed you how to color them using photo oils (page 17), and he gave me a couple of copies to experiment with. We thought it would be interesting to see how different people handle tinting the same print. Here I chose colored pencils as my medium—easily available, user-friendly, and a terrific tinting medium, as long as the print is on matte paper. You can color on a dry photo allowing the pencil strokes to show for a "drawing" look. For a smoother final, apply your pencil strokes very smoothly and blend with a soft brush dampened with odorless art thinner.

Step 1 I began with a light yellow pencil and colored all three pears completely, making certain that my strokes always followed all the contours of the fruit. I continued coloring them with the yellow pencil until all three were covered evenly, giving me a solid base coat for adding details.

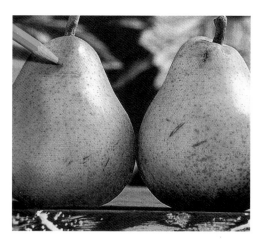

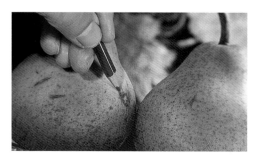

Step 2 Next I used a light brown pencil to add the darker tones, continuing to stroke in the direction of the pears' contours. Notice how the light brown adds to the natural color of the skin. Then I used a dark brown pencil to add warmth and to enhance the inevitable bruises and mars on the pears' delicate skin.

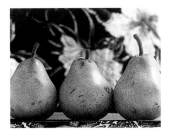 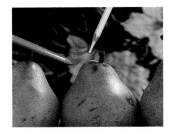

Step 3 Next I used a light green pencil and lightly colored in a few areas on each pear, which added a feeling of life. I began to color the background flowers using a dark pink for the center and a light pink for the petals on the flower in the upper right corner. I colored the leaves using a dark green, a light green, and a white pencil to blend the colors.

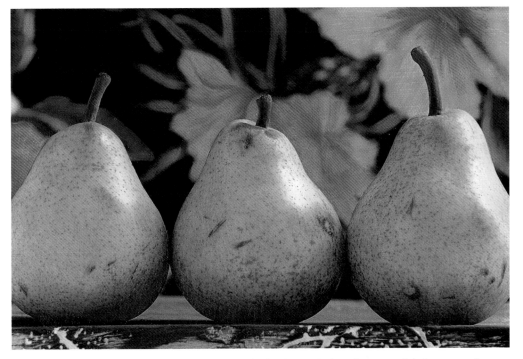

Step 4 Once the leaves were tinted, I suggested a bit of soft color on the branches using a light brown pencil. There! I made a pleasing composition using something as simple as colored pencils.

Be Creative

"Patriotic Pears" was hand tinted using artists' watercolors. Coloring media that are capable of adding texture to a photo can give a more "painterly" look to your subject—very different from the smoother photo oils and dyes.

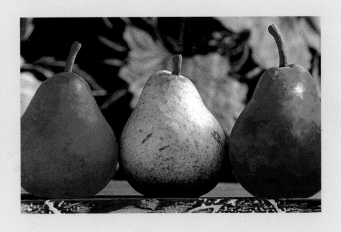

Mixed Media:
Watercolor and Colored Pencils

To tint with a combination of watercolor and colored pencil media, you will need to prepare the surface of the photo first. If you try this combination on a photo of your own, which I strongly encourage you to do, spray the photo with workable fixative to protect it from the water. Then add an acrylic flow medium (see page 6) to the watercolor to improve the flow of color and ensure that it adheres to the photo surface.

Step 1 Before coloring, I taped all four edges of the photo with drafting tape to help maintain a clean border. Keep in mind that even when masked, watercolor sometimes works its way under the tape, so take extra care when painting near the edges. Then I prepared the first medium to apply: watercolor.

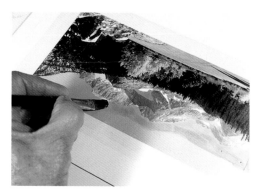

Step 2 First I turned the photo upside down and tilted it slightly to allow the paint to run toward the top of the photo. Beginning with ultramarine blue, I stroked an edge against the mountain. Working quickly so the color stayed wet, I continued coloring the sky, making strokes at a slight angle until it was all covered.

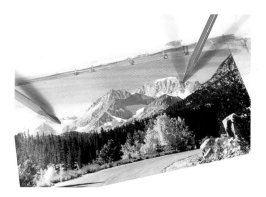

Step 3 Once the sky area was dry, I was ready to add touches with colored pencil. I colored the mountain, the middle ground, and the foreground rock using a light orange pencil for light areas and a purple one for the shadows.

Step 4 Now I went back to watercolor. Using Hooker's green deep, I painted a thin wash over the trees. I then washed in a pinkish gray for the foreground rocks and the road shoulder. I grayed the color a bit further for the cast shadows on the road.

Step 5 Next I used a small, round-pointed brush to tap in dark greens (Hooker's green deep plus a bit of burnt umber), light greens (permanent green light plus a speck of cadmium orange), and bronze greens (permanent green light plus yellow ochre and a speck of cadmium red light). Using a mixture of cadmium orange, cadmium red light, and burnt sienna (graying the mix as needed with ultramarine blue), I made tapping strokes (called *pointillism*) to create an uneven dot pattern for the dark golden foliage.

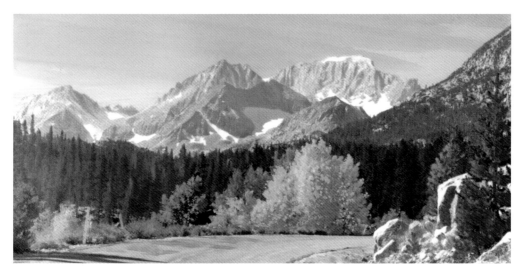

Step 6 To conclude, I used combinations of greens, oranges, and tans to paint the trees and bushes around the aspens. Burnt sienna, cadmium orange, and the two previous greens made great combinations for the foliage. Finally, I used a wash of burnt sienna and permanent rose to accent the bushes along the road.

Flower Study in Oil Pastel

Oil pastels can be made to appear opaque or translucent, and they can be wetted and blended with turpentine or odorless art thinner to create special effects. They are very versatile and fun to use on photos. The colors are very intense when applied thickly to a dry surface. Several colors can also be applied over one another as a mixing blend.

Step 1 I began by applying yellow pastel to the center of the flower and then scattering several little dots of light pink throughout the yellow.

Step 2 Next I blended my colors lightly with a small brush dampened with odorless art thinner (if you substitute turpentine, use with adequate ventilation).

Step 3 With the rounded end of a brush handle, I gently scraped away excess colors to accent the shapes of the anthers and stigmas.

Step 4 Then I applied a fairly heavy layer of medium yellow paste on the daisy, making sure my strokes followed the direction of the petals.

Step 5 Again, I blended the colors together with a brush dampened with odorless art thinner. When you blend this way, be careful not to get the brush overly wet, or you'll remove the color.

Step 6 I painted in a rich red around the inside of the petals, making strokes closest to the flower center stronger in color. To achieve a tapered stroke, I used a push-and-lift technique here.

Step 7 Once again, I blended with a damp brush and art thinner.

Step 8 Using a sharpened black pastel stick, I created shadows and accented the deep values.

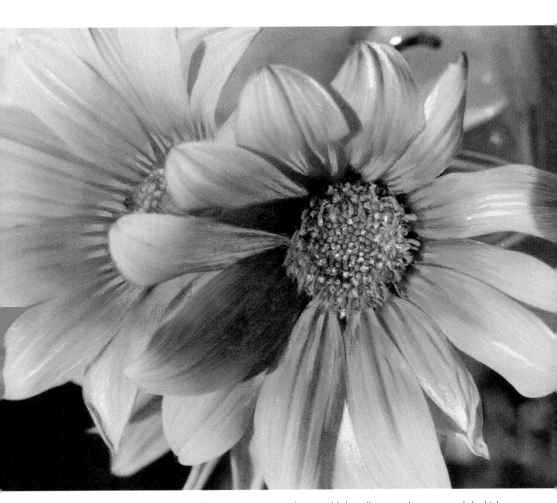

Step 9 To complete this piece, I painted in light accents using a sharpened light yellow pastel, accentuated the highlights, and placed a few additional dots in the center of the flower. These were the finishing touches that maintained the dramatic contrasts between the lights and the darks.

Two Oil Pastel Techniques

This photo of a glorious Hawaiian sunset taken by my wife, Beverly, shows the impressionistic qualities that can be achieved with oil pastels. For this example, I used two techniques. In the first series of steps, I used oil pastel sticks alone, and during the second series of steps, I used turpentine to blend the pastels. This photo has a lot of very dark areas, and transparent colors (such as watercolor or markers) will not cover them well. Oil pastels are both opaque and semi-opaque, making them perfect for this kind of print. They are also well suited for this very loose, free-flowing artistic expression.

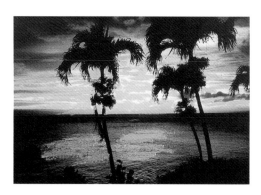

Step 1 I began with light yellow pastel and painted in the basic glow of the sun with horizontal strokes, continuing into the water.

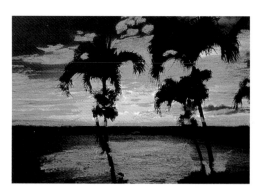

Step 2 I added deeper glow colors using a medium pink and then added more pink judiciously throughout the sky and into the water.

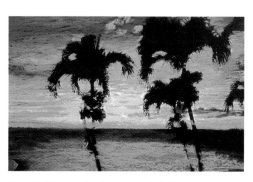

Step 4 I placed a clean sheet of paper on the horizon to mask off the bottom and help me make the horizon line straight. Then I added pink to the sky and a reddish purple to the trees and foreground, using free-form strokes.

Step 3 Using both a light and a dark blue pastel, I put color into the sky, pressing gently to blend with the previous colors. Next I added deeper red in the water and the edges of the sky.

Step 5 I loaded a small, flat-styled sable brush with odorless art thinner and squeezed out as much liquid as I could. Then I used the damp-dry brush to remove color from tree trunks, fronds, and any place I had covered by accident.

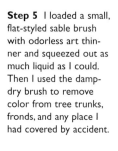

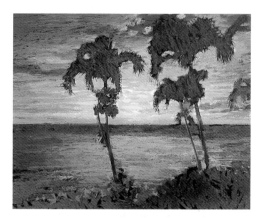

Step 6 Here I accented the light blues of the sky, keeping the composition impressionistic—loose and fresh in color.

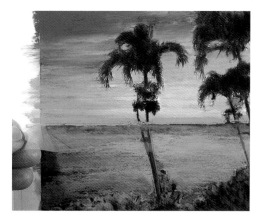

Step 7 Using a brush slightly dampened with thinner, I began blending the sky area, stroking with the flat of the brush at an ever-so-gentle angle. Then I continued blending in both the sky and the water, creating a smooth background color.

Step 8 Again, I used a brush dampened with thinner to push color toward the edges of the tree forms. I also smeared some color and removed a bit of pastel from the foreground. To keep the horizon straight when blending, I covered it with tape.

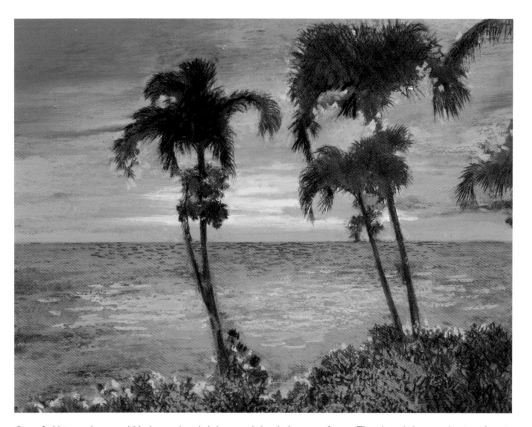

Step 9 Using a sharpened black pastel stick, I deepened the dark areas of trees. Then I used the round point of a brush handle to gently remove colors that had overlapped into unwanted areas. I also scraped out a ripple pattern in the distant sea, cleaned up palm fronds, and created a subtle pattern in the foreground. Then I applied a pink texture accent in the foreground and around bushes. To finish, I added light pink highlights for accents and strengthened any other colors I thought needed to be brighter.

Displaying Your Tinted Photos

After you've finished hand coloring your photos, you certainly don't want to hide them away—so display them! A professional job of matting and framing will enhance your tinted photos and really show them off.

Protect Your Photo Artwork

Spray finishes, sold in art stores in aerosol cans, are optional, but they do protect your finished artwork from moisture and dirt, plus they add a uniform matte or glossy sheen. Take care when using spray finishes, however, because breathing their fumes is extremely harmful. They also tend to darken your colors, something you may or may not like. If you've tinted with photo oils, you can protect your print with the special photo protectant sold with the photo oils.

come with glass fronts, but you can also use acrylic, which is lighter in weight (a real consideration when framing large pieces).

Hanging

Light is the number-one enemy of hand-tinted photos, so don't hang them in direct sunlight or near fluorescent lighting. Also avoid locations such as the kitchen or bath or spots near heat registers and fireplaces; the moisture and temperature changes can damage your print.

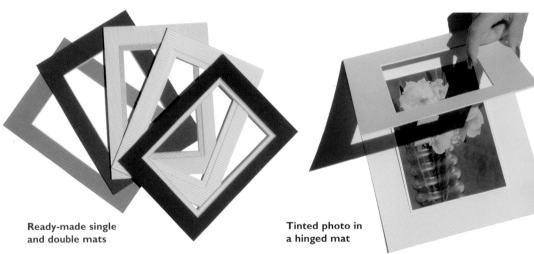

Ready-made single and double mats

Tinted photo in a hinged mat

Matting and Framing

Matting before framing is important because it keeps your art from touching the piece of glass or acrylic under the frame. You can buy pre-cut mats or cut them yourself. Standard-sized mats fit standard-sized frames, which are always less expensive than custom sizes. Sign your name lightly in pencil on the right side of the mat, not on the photo. If you choose to title your work, print it on the left side of the mat. Ready-made frames

Photo Albums

I like to group my smaller tinted works in albums, attached with photo corners and interlaced with acid-free tissue pages. Never put your photos under plastic; both the coloring medium and the first layer of the photo surface may stick to the plastic and come off, ruining all your efforts. Frame, hang, and store your hand-colored photographs as you would any fine work of art—because that is just exactly what they are!